Photostats *Felix Gonzalez-Torres*

with writings by Mónica de la Torre and Ann Lauterbach

siglio **2020**

Cover, book design, and typesetting by Natalie Kraft.

The editors extend warmest thanks to the Felix Gonzalez-Torres Foundation, Andrea Rosen, and Emilie Keldie, for their collaboration, generosity, and insights.

More information about Felix Gonzalez-Torres at www.felixgonzalez-torresfoundation.org.

FIRST EDITION | ISBN: 978-1-938221-26-2 | Printed and bound in China

siglio uncommon books at the intersection of art & literature
PO BOX 111, Catskill, New York 12414 Tel: 310-857-6935 www.sigliopress.com

Available to the trade through D.A.P./Artbook.com
75 Broad Street, Suite 630, New York, NY 10004
Tel: 212-627-1999 Fax: 212-627-9484

1

*Patty Hearst 1975 Jaws 1975 Vietnam
1975 Watergate 1973 Bruce Lee 1973
Munich 1972 Waterbeds 1971 Jackie 1968*

New Life Forms Patents 1987 Ollie 1986 Anti-frost Bacteria 1987 MTV 1983 National Security Council 1985 Dow Jones 2000 PTL 1987 National Jones Security Bacteria 1988

3

Pol Pot 1975 Prague 1968 Robocop 1987 H Bomb 1954 Wheel of Fortune 1988 Spud

4

Bitburg Cemetery 1985 Walkman 1979
Cape Town 1985 Water-proof mascara
1971 Personal computer 1981 TLC

5

Poland 1939 Pearl Harbor 1941 Nuremberg 1946 —
Ike 1952 Geneva 1955 LBJ 1964 Bruce Lee 1973

6

Helms Amendment 1987 Anita Bryant 1977 High-Tech 1980 Cardinal O'Connor 1988 Bavaria 1986 White Night Riots 1979 F.D.A. 1985

*Center for Disease Control 1981 Streakers 1974
Go-Go Boots 1965 Barbie Doll 1960 Hula hoopla
1958 Disneyland 1955 3-D Movies 1952 Boo-Boo*

8

tic-tac 1974 Spam 1970 National Rifle Association 1988 Gaza Strip 1963 The Pope 1987 Patient Zero

9

Head Start 1965 L.A. Olympics 1984 Willie Horton 1988 Civil Rights Act 1964
War on Poverty 1964 Trickle Down Economy 1980 L.A. Rebellion 1992 Freedom
Summer 1964 Montgomery Bus Boycott 1955 Watts 1965 EuroDisney 1992

B-2 Stealth Bomber 1982 V-22 Osprey Antisub Plane 1983
A-6 Intruder Fighter 1984 Aquila Drone (remote-piloted) 1987
F/A-18 Jet Fighter 1982 Wedtech 1986 Stinger anti-aircraft
missle 1985 Dirty Harry 1988 Maverick Missile 1987 SDI

11

Alabama 1964 Safer Sex 1985 Disco Donuts 1979 Cardinal O'Connor 1987 Klaus Barbie 1944 Napalm 1972 C.O.D.

supreme 1986 court crash stock market crash 1929 sodomy stock market court stock supreme 1987

13

Diana Princess North Zero Oliver Patient
Helms Disco Waldheim Bag Pope Poppers Tut

1
"Untitled"
1988
Framed photostat
10 1/4 x 13 inches
Edition of 3, 1 AP

2
"Untitled"
1988
Framed photostat
9 x 11 inches
Edition of 2, 1 AP

3
"Untitled"
1988
Framed photostat
10 1/2 x 11 3/4 inches
Edition of 1, 1 AP

4
"Untitled"
1987
Framed photostat
8 1/4 x 10 1/4 inches
Edition of 1, 1 AP with 2 additional APs

5
"Untitled"
1988
Framed photostat
10 1/2 x 13 inches
Edition of 1, 1 AP

6
"Untitled"
1988
Framed photostat
11 x 14 inches
Edition of 2, 1 AP with 1 additional AP

7
"Untitled" (1988)
1988
Framed photostat
10 1/4 x 13 inches
Edition of 1, 1 AP

8
"Untitled"
1988
Framed photostat
10 1/2 x 11 3/4 inches
Edition of 1, 1 AP

9
"Untitled"
1992
Framed photostat
12 5/8 x 16 5/8 inches
Edition of 4, 1 AP

10
"Untitled" (1988)
1988
Framed photostat
8 1/4 x 10 1/4 inches
Edition of 2, 1 AP

11
"Untitled"
1987
Framed photostat
8 1/2 x 10 3/8 inches
Edition of 3, 1 AP

12
"Untitled"
1988
Framed photostat
8 1/4 x 10 1/4 inches
Edition of 3, 1 AP

13
"Untitled"
1988
Framed photostat
10 1/2 x 13 inches
Edition of 1, 1 AP

Photograph that follows:

"Untitled"
1992
Framed photostat
12 5/8 x 16 5/8 inches
Edition of 4, 1 AP

Photographer: Oren Slor
Image courtesy of Andrea Rosen Gallery, New York

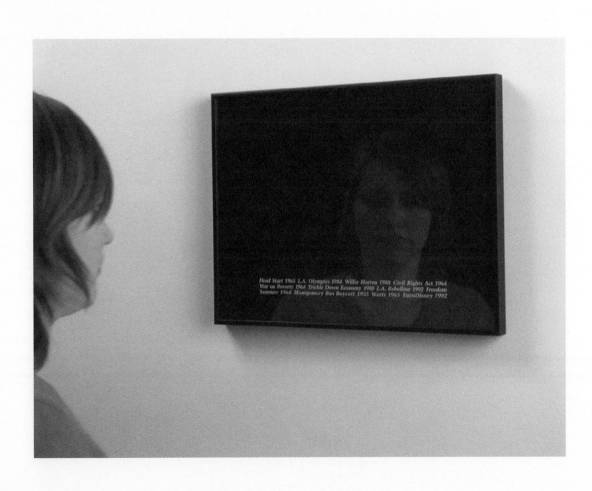

To Be an Infiltrator MÓNICA DE LA TORRE

Time the substantial we, / epochal and great, as only we can see it, our particular.

—Alice Notley

No one wants to be defined by history's contingencies, by catastrophe, but attempting to ignore how they shape us would be as ludicrous as trying to stop the clock. What if instead we broke down the chain of events leading to them, undoing their fatal sequence and leaving their parts open for reassembly? Is this what's at stake in Gonzalez-Torres's photostat works? Here, in this book, they appear as coded messages awaiting decipherment, but they're equally apt on gallery walls as reminders that no matter how open or walled-off any space may be, it escapes neither interconnectedness nor time's inexorable march.

Unlike the stars, we do not write, luminously, on a dark field (Mallarmé). Yet Gonzalez-Torres's inscriptions do act as constellations, as celestial alphabet. Events worth remembering, the count of years—they are light beams orienting us as we go on forgetting. Each cluster of dates and references displays its own oblique associative logic. The larger narrative it may or may not point to can be searingly legible or obscure to varying degrees. Regardless, those gaps between elements in each of the clusters are openings inviting us to fill in the blanks by bringing in our own associations, personal histories, and biases.

I took apart dates and historical events and remembered or discovered what occurred then

that might have had a bearing on him. Let's not forget he was a transplant, a politically minded one, who identified specifically as American but was born in Cuba and raised in Puerto Rico: two places with a complex relationship to the US. I wonder with whom in the art world he would've spoken in Spanish and how his conversations would've taken shape according to what he'd say in one language and not the other? Did he think of this? Am I projecting? He carefully avoided labels.

Apropos of not making art *about* being gay, Gonzalez-Torres said to Ross Bleckner in a *BOMB* interview that his work was about love and infiltration. "It's beautiful; people get into it. But then, the title or something, if you look really closely at the work, gives out that it's something else."[1] To look closely here involves taking a deep-dive into history's ash heap, getting lost in the process, knowing there's no one way to read the works. Oddly rhyming shards emerge, resonant shards that seem to prove the existence of a universe in which the future's already happened.

*

Lest Chile becomes "another Cuba,"[2] the Nixon administration encourages a military coup against democratically elected Salvador Allende in the early 1970s. Weeks after Allende's overthrow in 1973, the Weather Underground bombs the ITT Corporation's offices in New York and Rome for its involvement in the coup. In 1974 Hans Haacke makes an artwork exposing the Guggenheim Museum's trustees' ties to the Kennecott Copper Corporation and its attempts to undermine Chile's economy after Allende's regime expropriated its mines. In 1975, a killer shark in a film symbolizes a miscellany of sociopolitical anxieties. A Gonzalez-Torres exhibition opens at the Guggenheim in 1995.

*

In 1983, Bowie asks MTV host: "I'm just floored by the fact that there are so few black artists being featured . . . Why is that?"[3] One of 285 music videos featured that year is in Spanish: Italian disco duo Righeira's "No tengo dinero."[4] In 1985, the Organization of Volunteers for the Puerto Rican Revolution claims responsibility for shooting a US Army recruiting officer: "Yankee jails are becoming filled with . . . our patriots; . . . prepare your cemeteries because we're going to fill them with your mercenaries."[5] In 1987, Harvard University is awarded the first new-life form patent for the cancer-prone, transgenic oncomouse.

*

In 1975, Cambodia's new leadership embarks on a gruesome path towards self-reliance and "clearing the country of the filth and garbage left behind by the war of aggression of the US imperialists and their lackeys."[6] In 1968, the US Embassy is attacked in Rio. Student uprisings against autocratic regimes, and the sentiment leading Peruvian students to shower Vice-President Nixon with garbage while on a goodwill tour a decade earlier, sweep across Latin America.[7] In the 1987 *Robocop*, a cyborg is developed after a self-sufficient robot designed for Detroit's urban pacification kills a trustee of the very corporation that created it.

*

There's a video by Felix Gonzalez-Torres made in 1979, the year he arrived in the US and portable music was born. Shirtless, he speaks to the camera in Spanish while writing on a blackboard. He remembers being put on a plane to Spain with his sister as a child. Remembers priests and not

remembering his mother. He goes on half-remembering an upsetting story in which memories and stories are traps tangling him up, always the same old memories and stories tangling him up. He points to the blackboard: "See, that's you in the middle of that jumble, all tangled up."[8]

*

In Bowers vs. Hardwick (1986), the Supreme Court upholds Georgia's sodomy laws criminalizing oral and anal sex between consenting adults. A public drinking citation outside Hardwick's workplace, a gay bar in Atlanta, had turned into an arrest warrant allowing a police officer to walk into the defendant's home and discover him engaging in oral sex with his male partner. Justice Blackmun's dissenting opinion—one of two—is written by openly gay clerk Pamela S. Karlan. Testifying during Trump's impeachment trial in 2019, she would quip: "The president can name his son Barron, but he can't make him a baron."[9]

*

At a televised press conference in 1977, anti-gay crusader, once beauty queen Anita Bryant prays that the man who just put a pie in her face "be delivered from his deviant lifestyle." "We can't stand the garbage you spout," he shouts back.[10] The FDA licenses the first blood test for AIDS in 1985. Rock Hudson, the first celebrity to publicize his diagnosis, dies of AIDS-related illness that year. A 1949 screen test had catapulted him to stardom: " . . . for thirty days and nights, we took a steady beating. More than half my platoon were killed. I never expected to come out alive."[11]

*

In 1952, Fulgencio Batista stages a military coup in Cuba. Recklessly corrupt, he is backed by the Eisenhower administration while the public's discontent, which will eventually lead Fidel Castro to overthrow him, keeps mounting. American mobster Meyer Lansky, aka the "Mob's Accountant," has full control of Cuba's gambling casinos then. Batista dies in 1973, and so does Bruce Lee. Lee's poem "The Silent Flute" was the basis of a screenplay for an eponymous film. An excerpt reads: "Now I see that I will never find the light / Unless, like the candle, I am my own fuel, / Consuming myself."[12]

*

Patient Zero (originally O for "out-of-California") contracted what was considered a rare cancer in 1981. I write these words during the coronavirus pandemic. The irony of stating this isn't lost on me; only the readers of an inconceivable future would need to be reminded that the world as we'd known it came to a halt in 2020. In various Classical texts, *Pandêmos*—the common to all people—serves as Eros and Aphrodite's surname and is synonymous with sensual love.[13] It is only just, Gonzalez-Torres's abiding demand that we partake of a radical poiesis at the intersection of love and the public.

*

In a 1970s Dick Tracy-style commercial, an orange tic-tac's flavor "fizzes in a rumba" on the detective's tongue.[14] When the American market begins calorie-counting later on, cunning replaces wit: tic-tacs, which helped consumers "get a kick out of life" now become the "one-and-a-half calorie breath mint."[15] In a Monty Python 1972 sketch, SPAM—ubiquitous in the UK during wartime—is undesirable no matter how it's spun. Unsolicited advertising email is named after the sketch. The

first deliberate spam for a network's users to read is posted in 1994. Its subject: "Global Alert for All: Jesus is Coming Soon."[16]

<div align="center">*</div>

Attorney General William Barr sends 2000 military troops to quell riots following the 1992 acquittal of the LAPD officers who'd battered Rodney King: "We're not going to tolerate any of this stuff out in the streets."[17] During the 1965 Watts Riots, 14,000 troops had descended on Los Angeles.[18] The Insurrection Act—conceived as protection "against hostile incursions of the Indians"[19]—is invoked again in 2020. Trump summons the National Guard to control protests against George Floyd's murder. Immediately after, Attorney General Barr accompanies him to St. John's Church for a photo op. Heard again throughout American cities: "No Justice, No Peace!"

<div align="center">*</div>

The 1988 action thriller *The Dead Pool* is the final installment of the "Dirty Harry" series in which Clint Eastwood, a pro-gun self-declared libertarian, plays a maverick inspector. "You forgot your fortune cookie; it says you're shit out of luck," he snaps, as he pulls out a Smith & Wesson Model 29 to shoot a robber at a Chinese restaurant.[20] During the American Civil War, Smith and Wesson became the most popular revolvers among soldiers of both sides using them for self-defense.[21] During the 2012 Republican National Convention, Eastwood improvised a cringe-worthy pro-Romney speech while speaking to an empty chair.

<div align="center">*</div>

In defiance of the Civil Rights Act, Alabama's electors refuse to pledge votes to Lyndon B. Johnson in 1964, and the state's presidential election ballot has no democratic contender. In the 1950s, when gentrification causes artists and poets to move eastward from Greenwich Village, the area once known as Little Germany that later became home to Eastern European immigrants is re-branded as the East Village. On Third Ave. and 14th Street, where the Five Napkin Burger chain now thrives, there once stood, in the mid-1980s, the 24-hour coffee shop Disco Donuts. Above it was the lesbian bar "Carmelita's Reception House."[22]

*

William James: "Many things come to be thought by us as past, not because of any intrinsic quality of their own, but rather because they are associated with other things which for us signify pastness. . . . What is the *original* of our experience of pastness, from whence we get the meaning of the term?"[23] car market crash smash hit big bang sudden great drop depression catastrophe collision black monday speculative dotcom bubble bankruptcy chapters steep revenue cling-clang loss eco-nomic stars recession collide crisis crack epidemic break dance financial thump-thump panic boom box bounce back behavior immunity herd cats . . .

Endnotes

[1] Ross Bleckner, "Felix Gonzalez-Torres," *BOMB*, Issue 51, April 1, 1995.

[2] "CIA Activities in Chile," September 18, 2000, https://www.cia.gov/library/reports/general-reports-1/chile/#5.

[3] "David Bowie Criticizes MTV for Not Playing Videos by Black Artists/MTV News," https://www.youtube.com/watch?v=XZGiVzIr8Qg.

[4] "Music Videos Released in 1983 (285)," https://imvdb.com/calendar/1983.

[5] "Around The Nation; Group in Puerto Rico Threatens More Attacks," *New York Times*, Nov. 8, 1985.

[6] "Lon Nol Is Accused," *New York Times*, May 8, 1975.

[7] Malcolm W. Brown, "Student Unrest Plagues Latin America," *New York Times*, June 30, 1968.

[8] "5 Piezas en Vídeo de Félix González 1979," https://www.youtube.com/watch?v=8f_wk8xmEYw&t=2960s. (My translation.)

[9] "Live Blog/Analysis After the Judiciary Committee Impeachment Hearing," NBC News, Dec. 4, 2019, https://www.nbcnews.com/politics/trump-impeachment-inquiry/live-blog/impeachment-hearing-live-updates-judiciary-committee-n1095001/ncrd1095936#liveBlogHeader.

[10] "Anita Bryant's Pie to the Face," https://www.youtube.com/watch?v=5tHGmSh7f-0.

[11] "Rock Hudson's First Screen Test," https://www.youtube.com/watch?v=iFlLibZ4F8U.

[12] Harriet Staff, "On the Poetry of Bruce Lee," Poetry Foundation, Oct. 4, 2011.

[13] "Dictionary of Greek and Roman Biography and Mythology/Pandemos, "https://en.wikisource.org/wiki/Dictionary_of_Greek_and_Roman_Biography_and_Mythology/Pandemos.

[14] "Tic Tac advert from the seventies," https://www.youtube.com/watch?v=4qZqmp_0blo.

[15] "Tic-Tac's Turnaround," *New York Times*, April 4, 2019.

[16] "History of Email Spam," https://en.wikipedia.org/wiki/History_of_email_spam.

[17] "What You Should Know about the Civil Rights Record of William Barr," A Brief by the NAACP Legal Defense and Educational Fund, Inc., https://www.judiciary.senate.gov/imo/media/doc/LDF.pdf.

[18] Civil Rights Digital Library, "Watts Riots," http://crdl.usg.edu/cgi/crdl?skipfacets=1&numrecs=25&action=query&term_a=watts_riots&index_a=kw&_cc=1

[19] "Defense Primer: Legal Authorities for the Use of Military Forces," Congressional Research Service Jan. 3, 2020, https://crsreports.congress.gov/product/pdf/IF/IF10539.

[20] The Internet Movie Firearms Database, "The Dead Pool," http://www.imfdb.org/wiki/Dead_Pool,_The#:~:text=Inspector%20%22Dirty%20Harry%22%20Callahan%20(,the%20movie%20The%20Dead%20Pool.

[21] "Smith and Wesson," https://en.wikipedia.org/wiki/Smith_%26_Wesson.

[22] "14th and Third," http://vanishingnewyork.blogspot.com/2009/07/14th-3rd.html.

[23] William James, *The Principles of Psychology*, New York: Henry Holt & Co., 1890.

Photostats Felix Gonzalez-Torres

with writings by Mónica de la Torre and Ann Lauterbach

siglio **2020**

Photostats edited by Richard Kraft and Lisa Pearson © 2020 Siglio Press and the Felix Gonzalez-Torres Foundation.

All individual works by Felix Gonzalez-Torres © Felix Gonzalez-Torres, courtesy of the Felix Gonzalez-Torres Foundation.

"To Be an Infiltrator" © 2020 Mónica de la Torre
"Untitled (Event)" © 2020 Ann Lauterbach.

Cover, book design, and typesetting by Natalie Kraft.

The editors extend warmest thanks to the Felix Gonzalez-Torres Foundation, Andrea Rosen, and Emilie Keldie, for their collaboration, generosity, and insights.

More information about Felix Gonzalez-Torres at www.felixgonzalez-torresfoundation.org.

FIRST EDITION | ISBN: 978-1-938221-26-2 | Printed and bound in China

siglio uncommon books at the intersection of art & literature
PO BOX 111, Catskill, New York 12414 Tel: 310-857-6935 www.sigliopress.com

Available to the trade through D.A.P./Artbook.com
75 Broad Street, Suite 630, New York, NY 10004
Tel: 212-627-1999 Fax: 212-627-9484

1

Patty Hearst 1975 Jaws 1975 Vietnam 1975 Watergate 1973 Bruce Lee 1973 Munich 1972 Waterbeds 1971 Jackie 1968

New Life Forms Patents 1987 Ollie 1986 Anti-frost Bacteria 1987 MTV 1983 National Security Council 1985 Dow Jones 2000 PTL 1987 National Jones Security Bacteria 1988

3

Pol Pot 1975 Prague 1968 Robocop 1987 H Bomb 1954 Wheel of Fortune 1988 Spud

4

Bitburg Cemetery 1985 Walkman 1979
Cape Town 1985 Water-proof mascara
1971 Personal computer 1981 TLC

Poland 1939 Pearl Harbor 1941 Nuremberg 1946
Ike 1952 Geneva 1955 LBJ 1964 Bruce Lee 1973

Helms Amendment 1987 Anita Bryant 1977 High-Tech 1980 Cardinal O'Connor 1988 Bavaria 1986 White Night Riots 1979 F.D.A. 1985

7

*Center for Disease Control 1981 Streakers 1974
Go-Go Boots 1965 Barbie Doll 1960 Hula hoopla
1958 Disneyland 1955 3-D Movies 1952 Boo-Boo*

8

tic-tac 1974 Spam 1970 National Rifle Association 1988 Gaza Strip 1963 The Pope 1987 Patient Zero

9

Head Start 1965 L.A. Olympics 1984 Willie Horton 1988 Civil Rights Act 1964
War on Poverty 1964 Trickle Down Economy 1980 L.A. Rebellion 1992 Freedom
Summer 1964 Montgomery Bus Boycott 1955 Watts 1965 EuroDisney 1992

10

B-2 Stealth Bomber 1982 V-22 Osprey Antisub Plane 1983 A-6 Intruder Fighter 1984 Aquila Drone (remote-piloted) 1987 F/A-18 Jet Fighter 1982 Wedtech 1986 Stinger anti-aircraft missle 1985 Dirty Harry 1988 Maverick Missile 1987 SDI

11

Alabama 1964 Safer Sex 1985 Disco Donuts 1979 Cardinal O'Connor 1987 Klaus Barbie 1944 Napalm 1972 C.O.D.

12

*supreme 1986 court crash stock
market crash 1929 sodomy stock
market court stock supreme 1987*

13

Diana Princess North Zero Oliver Patient
Helms Disco Waldheim Bag Pope Poppers Tut

The preceding plates are details of the works listed below. They are reproduced in full in the other section of this book.

1
"Untitled"
1988
Framed photostat
10 1/4 x 13 inches
Edition of 3, 1 AP

2
"Untitled"
1988
Framed photostat
9 x 11 inches
Edition of 2, 1 AP

3
"Untitled"
1988
Framed photostat
10 1/2 x 11 3/4 inches
Edition of 1, 1 AP

4
"Untitled"
1987
Framed photostat
8 1/4 x 10 1/4 inches
Edition of 1, 1 AP with 2 additional APs

5
"Untitled"
1988
Framed photostat
10 1/2 x 13 inches
Edition of 1, 1 AP

6
"Untitled"
1988
Framed photostat
11 x 14 inches
Edition of 2, 1 AP with 1 additional AP

7
"Untitled" (1988)
1988
Framed photostat
10 1/4 x 13 inches
Edition of 1, 1 AP

8
"Untitled"
1988
Framed photostat
10 1/2 x 11 3/4 inches
Edition of 1, 1 AP

9
"Untitled"
1992
Framed photostat
12 5/8 x 16 5/8 inches
Edition of 4, 1 AP

10
"Untitled" (1988)
1988
Framed photostat
8 1/4 x 10 1/4 inches
Edition of 2, 1 AP

11
"Untitled"
1987
Framed photostat
8 1/2 x 10 3/8 inches
Edition of 3, 1 AP

12
"Untitled"
1988
Framed photostat
8 1/4 x 10 1/4 inches
Edition of 3, 1 AP

13
"Untitled"
1988
Framed photostat
10 1/2 x 13 inches
Edition of 1, 1 AP

Photograph that follows:

"Untitled"
1987
Framed photostat
8 1/2 x 10 3/8 inches
Edition of 3, 1 AP

Photographer: EPW Studio/Maris Hutchinson
Image courtesy of Andrea Rosen Gallery and
David Zwirner Gallery, New York

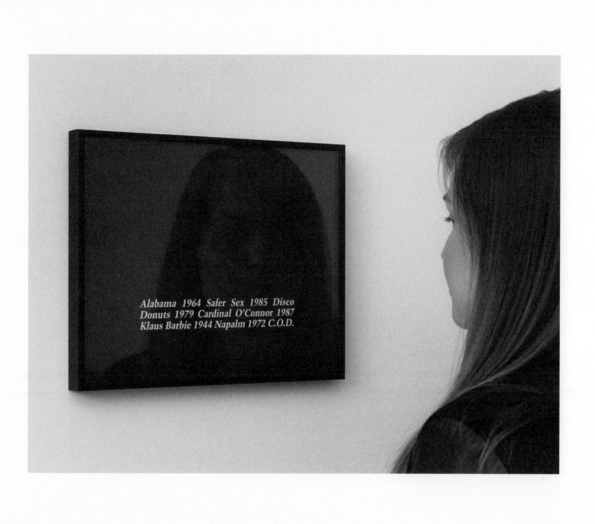

Untitled (Event) ANN LAUTERBACH

1.

The days are untitled. And then, and then, and then. Is this a list? A calendar? A Wednesday? Rain? The days are untitled. Even as they are stitched with photos of the emptied sky above the emptied streets and live updates in the realm of counting. Counting is not naming. One hundred, or twenty-nine thousand: nameless. Which one is called Cuba? Which one Ross?

The pause increases its domain, piecemeal, unobserved, trivial, masked. The corners are eroded, bending into new forms, but stationary, as if waiting, as if fundamental, neither redundant nor opaque. There is an airy detritus of the envelope gaining on us, the epicenter of a storm, the jargon of capital, the aspiring ghosts, awakened but nameless.

Slant awakened, sleepy in the aftermath. A tool of the ordinary spread like a shadow outward, shadow into night, night into never. Leaning into or across the path, horizontal, as if reading to rupture indifference. What other life? There, in the distance? This one unlisted, uncounted. And desire's saturated mission, encumbered by the perishable, by the floating agenda, wanting to be an event raised up over the neutral: one, two, three.

And the body's emoji, the disparate embrace of the audience? Heartless sign and contingent fact awaiting renown. Some horse is dying. Some flower. Air still above the museum's silent heap. Around the immaculate surfaces, signs. Please Do Not Touch. And so told in brief, the slogan's approach to living. And then? A child's habit of speech: tracking the day without consequence. An inertial listing toward a factless Paradise. Corpse wrapped in plastic. Who put that there? Who posed for that? The increments are tremendous.

And were they inconsolable in the aftermath? The undetectable region of unlikeness, after the numbers, after the counting. Signing off from the ravaged plateau, seeking the smallest increments on the turning plot and its present indictment, coded swiftly into the pretty colorless flower and the falling yellow rain's slant address. Index and citizen under the fearful, untitled passage. Self-portrait as invisible test: unquantifiable inhalations, patterns of a pulse.

2.

> Your death?—water
> spilled upon the ground—
> though water will mount again into
> rose-leaves—
> but you?—Would hold life still,
> even as a memory, when it is over,
> Benevolence is rare.
>
> —William Carlos Williams, "History," 1913

It was spring, remember? Before the trip to the contagious hospital, before the notion of a cruel intervention placed later on a billboard over the avenue. The doctor came to the house. There were glasses of water by the bedside, on the small table. No, it wasn't spring, it was autumn. Before the trip to the contagious hospital, before the notion of an intervention, later placed on a billboard over the avenue. It was autumn. No, it wasn't autumn. It was late winter, remember? Before the trip to the contagious hospital, and the moon was full like a huge pink bloom in the sky. Nobody saw the billboard in the moonlit sky.

3.

'T is frivolous to fix pedantically the date of particular inventions. They have all been invented over and over fifty times. Man is the arch machine of which all these shifts drawn from himself are toy models. He helps himself on each emergency by copying or duplicating his own structure, just so far as the need is.

—Emerson, "Fate," 1853

Are inventions events? The inventory has a story but you have to peel it away skin by transparent skin. Under this one, another, and under that, another. And then and then and then, the child, adding up events in a new geography of accounting. The child turns the pages, looking for his favorite truck. Who is Patient Zero? And one and one and one. Could someone bring a copy of *The Wings of the Dove*? There will be some delay now. Could someone bring a copy of *The Fire Next Time*?

There will be some delay now.

Shining particles are falling across space in a slow infinite curve.

4.

A season, a winter, a summer, an hour, a date, have a perfect individuality lacking nothing, even though this individuality is different from a thing or a subject.
 —Gilles Deleuze and Felix Guattari, "A Thousand Plateaus," 1987

Meanwhile, it is later. A green truck is passing a red truck. That was then and this is now. Patient Zero is dead, and the heroine is dead as well. Was she Lucy? Or was Lucy someone else, in another story, the one in the sky with diamonds? Or causing trouble with Ricardo. No, not Lucy. Was she Nancy? No, Nancy is in another book, she is lifting her skirt. Nancy is my friend. The trucks are gone now. Who saw the billboard in the sky? An audience of one. The days are untitled. There was a public, milling about, climbing the stairs, standing in the beautiful light of the cathedral. Is one a public? Is one the enemy?

Meanwhile, the count exceeds ten thousand.

We shall never be again as we were.

5.

The movement now began with the fact of two hundred million, and the movement was toward a unit of one, alone. Groups of more than one were now united not by a common history but by common characteristics. History became the history of demographics, the history of no-history.

—George W.S. Trow, "In the Context of No Context," 1980

What happened before these singularities? To whom do they refer, to you, to me? Homer was there, Ovid was there; Virgil. All their stories, all their *and then and then and then.* The world is choking with memories of the world, one after another. Better a list, a catalogue; better the brevity of a slogan or sign. Scott Burton: "Grouping artists by intentions or their choice of materials will create communities otherwise unrelated." Intentions and materials configure communities. Are words materials to be offered for intention? Some think so, pliant and reciprocal, pointing inward and outward at the same time. Yes!

What does it mean to say something changed a life? It may mean that things you believed or thought, things that caused your judgments to form, were altered. What a capacious and capricious word, thing. It contains multitudes. Is a word a thing? The child would tell us *word is a noun, therefore it is a thing, since nouns refer to things.* You knew (I knew) that certain assumptions about how art should look and behave, its acts in the world, were being questioned by many persons from many places at the same time. Was this a revolution? To have persons from many places simultaneously question assumed or received ideas about something? Mechanical reproduction, aura, photographs, heaps, shards, *Les mots et les choses*, the death of the author, inner experience. This is a list.

Once things have happened they cannot be altered. There they are, assigned forever to their place in history.

History is a noun. Is it a thing?

History, a thing that constellates inclusion under the sign: *what happened*; the rest, ephemeral as candy sucked in the mouth of a child bored at a museum. Slowly, the pile of candies on the floor of the room disappears, and the wrappers float in the air, and the floor is bare and the child wanders away into the unknown and someone else dies. And then the temper of exclusion seeks retribution, so *overlooked no more*, the paper of record retroactively revising its view of the significant dead. Fame is a grim vector, a predictive ghostly claim on the living who imagine themselves persisting after the body has gone cold and gray, included in the reckoning: *what happened*.

6.

"Six Years: The dematerializaton of the art object from 1966 to 1972: a cross-reference book of information on some esthetic boundaries: consisting of a bibliography into which are inserted fragmented text, art works, documents, interviews, and symposia, arranged chronologically and focused on so-called conceptual or information or idea art with mentions of such vaguely designated areas as minimal, anti-form, systems, earth, or process art, occurring now in the Americas, Europe, England, Australia, and Asia (with occasional political overtones), edited and annotated by Lucy R. Lippard." 1973

7.

And then you see that once words are things, they might be arranged in relation to each other, and that these relations ask to be interpreted, for without interpretation, they are merely mute objects, white ink on a black ground. You will have to come into view, be seen there, bending over the printed page, saying the words to yourself, and as you turn the pages, the words shift into new shapes of meaning, new contagions, affinities, constellations, and then you look up at a screen where there are black words on a white ground, and countless images, thousands of images, thousands of words without chronology, without sequence. You are immobile at your desk. The day is untitled.

Orpheus turned back; Walter Benjamin's angel of history turned back. This turning proposes that our conditions of subjection can be extended into things we love instead of the things we obey; and the responses of loved things can become an opportunity for changes in ourselves: stylizations, perversions.
> —Doug Ashford, "Empathy and Abstraction, (Excerpts)," 2013

8.

Or just disappearing when we look away.
> —Dave Hickey, "The Invisible Dragon: Four Essays on Beauty," 1993

The child is told: go to your room and think about what you have done or said or not done or not said to cause others, a whole world of others, to be angry, or sad, or hurt. And while you are in your room, count to ten thousand, to twenty thousand, to a hundred thousand. And then, when you look

out the window, what do you see? And when you go to your window, what do you hear? The streets are nearly empty. There are pigeons sitting on the curb. The sky is nearer than it was yesterday. The child picks up a book and begins to read.

> After the time the world was born, and the first
> Day of the sea and the earth and the sun had dawned,
> Much matter was added from beyond, seeds added
> Around us, and the great All flung into union;
> From these the sea and the earth can grow, from these
> The heavens extend their demesne and lift still higher
> Their lofty towers; from these the winds arise.
> For driven from all quarters the atoms are sorted
> Each to his own, and settle into kinds:
> Water settles with water, from atoms of earth the earth
> Grows; fire flints out the fire and air the air;
> Until to the utmost limit of growth all things
> Are led, made perfect by Creating Nature.

> —Lucretius, "On the Nature of Things," First Century, BC